Mystic Mandalas

Whymzykyl 1

Buhgz

Uncommon Patterns for Your

Adult Coloring Pleasure

by Randy Horn

www. SpectraGraf .com

Copyright © 2016 SpectraGraf.com

All rights reserved

(c)2016, Kenneth Randy Horn, and its affiliates and assigns and licensors All rights reserved. SpectraGraf Publishing Co. is a wholly owned company of Kenneth Randy Horn. A graphic logo of the word "SpectraGraf" is a Trademark of Kenneth Randy Horn. Trademarks may be registered in some jurisdictions. All other trademarks are the property of their respective owners. No claim to copyright is made for original U.S. Government Works. No portion of this book, including any images may be reproduced in any manner without the expressed written permission of the publisher, Kenneth Randy Horn or SpectraGraf Publishing Co. for any commercial purpose.

ISBN-13:
978-1535510011

ISBN-10:
1535510013

Introduction

Hi there!

I'm Randy and you are holding one of many in my line of Adult Coloring Books brought to you by www.SpectraGraf.com where you can find more great books and supplies for buckets of fun and relaxation, coloring to your heart's content.

(more on this in the back of this book)

Remember when you were just a kid and life was simple? Adult coloring books allow you to recapture those times when you can calm down, shift gears *and* create beautiful art often suitable for framing. So therapeutic.

Here we present the third of the Mystic Mandalas series, Whymzykyl and, specifically, Buhgz! These mandalas are some which Dee and I pulled out of our heads and represent her characters and my graphics.

Here, we have drawn them for you, and YOU get the sheer pleasure of bringing them to life!

Some tips on coloring your artwork:

1. Try using mixed-media for an even more diverse look, such as colored pencil in some areas mixed with watercolor washes in others.

2. When using crayons, try burnishing the wax with an artist's stump. In larger areas, burnish hard on the edges and lighten up toward the middle to create an almost stained glass look.

3. Always use the best materials you can afford. This doesn't necessarily mean "expensive". You'll find quality supplies at very reasonable prices at SpectraGraf. If you're going to spend hours creating your art, especially if you intend to frame some or all of them, don't waste your time with cheap colors.

4. Spend a couple bux on a color wheel. It will show you which colors are complimentary while giving you a better choice of color ranges… and they're cheap!

5. Try a monochromatic painting on one or more designs. This is where you choose various shades and tints of the same color, such as all blues. Strive for at least 3 shades/tints – light, medium and dark. The more you use, the nicer your artwork will be.

6. Embellish some areas of the same shape and color with a little matching glitter for a more whimsical look!

7. When using watercolor, pre-wet the larger areas and drop pigment into the center or only paint the edges and let the pigment spread on its own. This is a *great* way to get a stained-glass look and feel to your paintings. You'll want to frame these, for sure.

Notes:

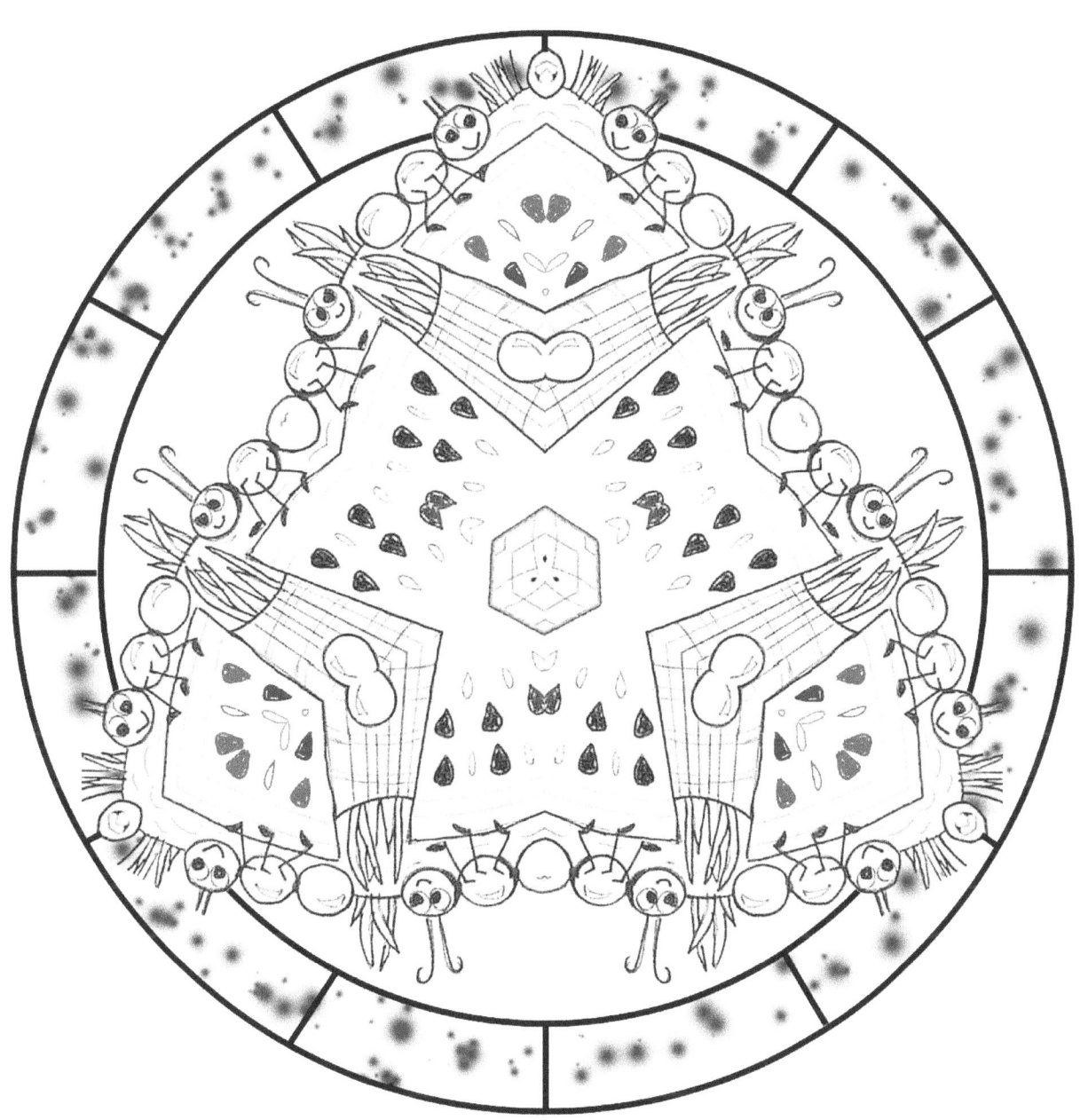

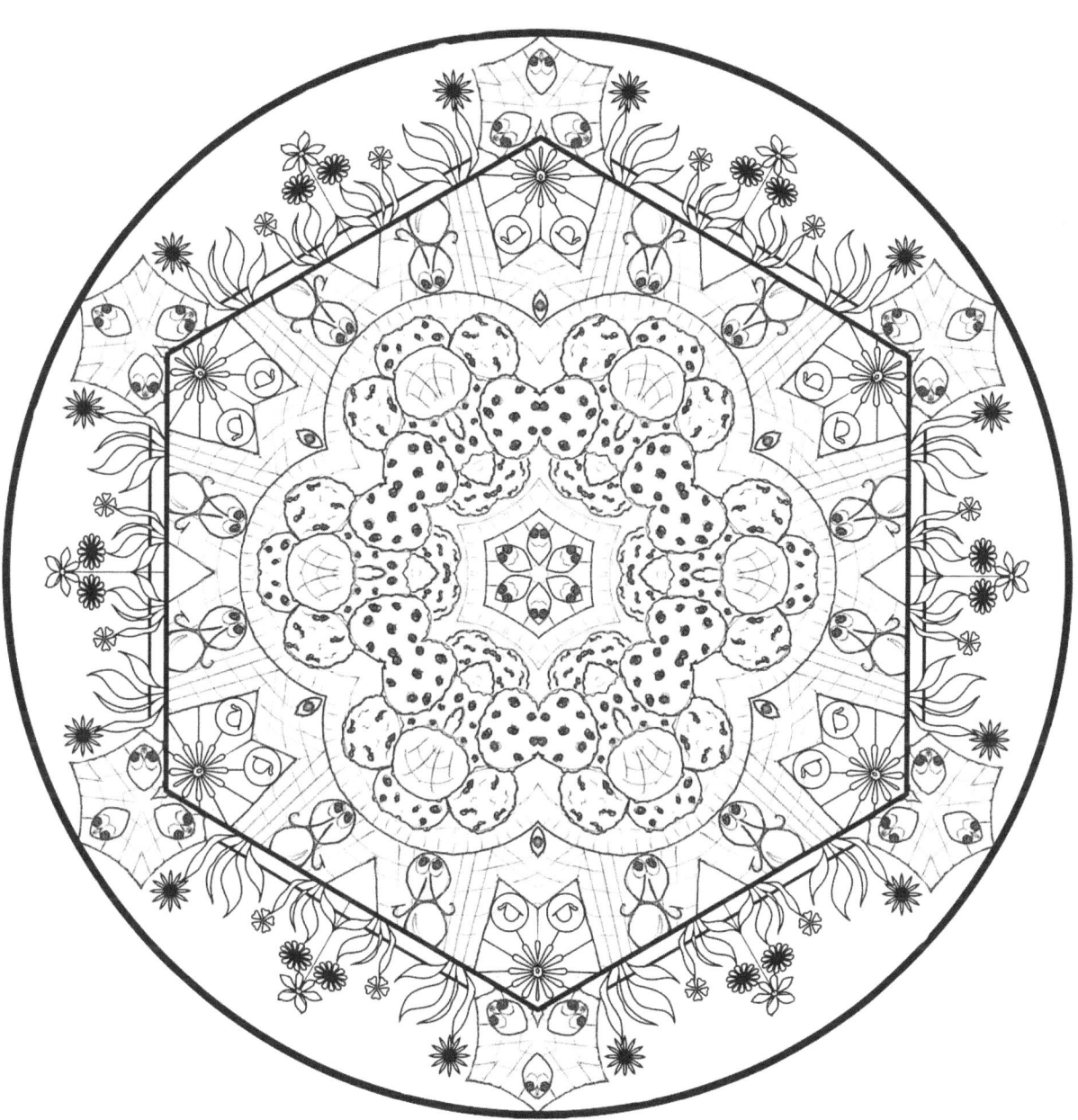

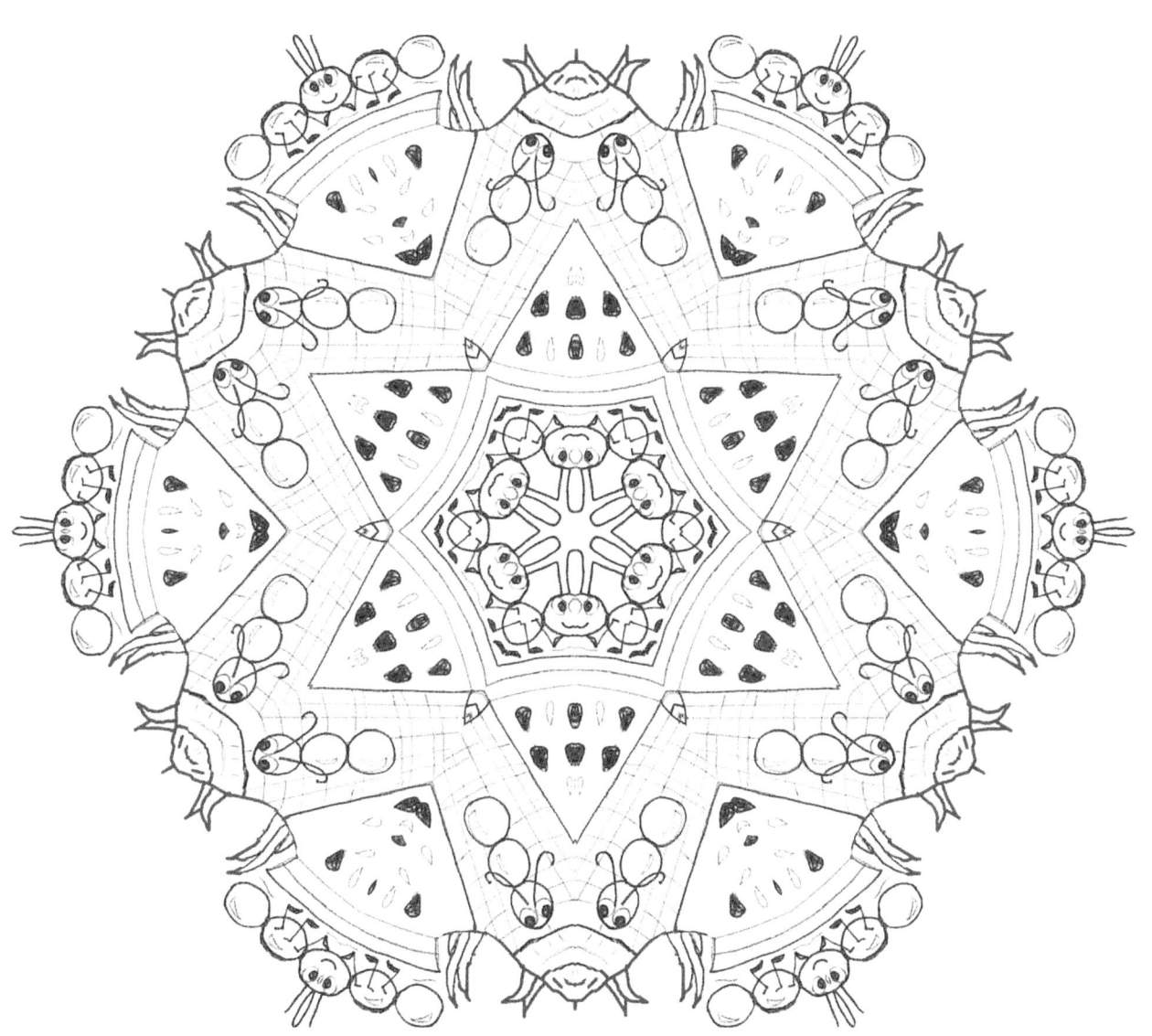

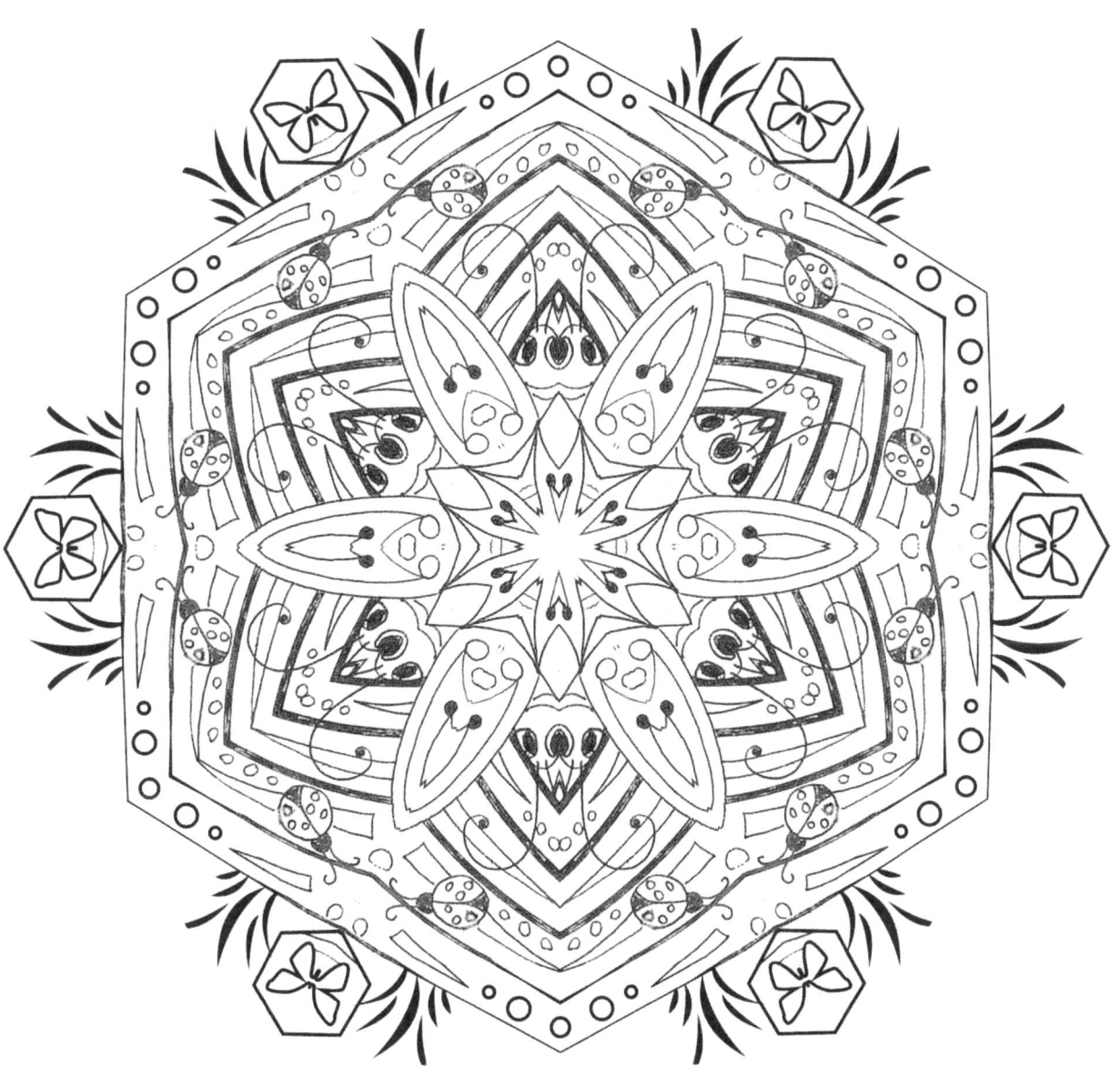

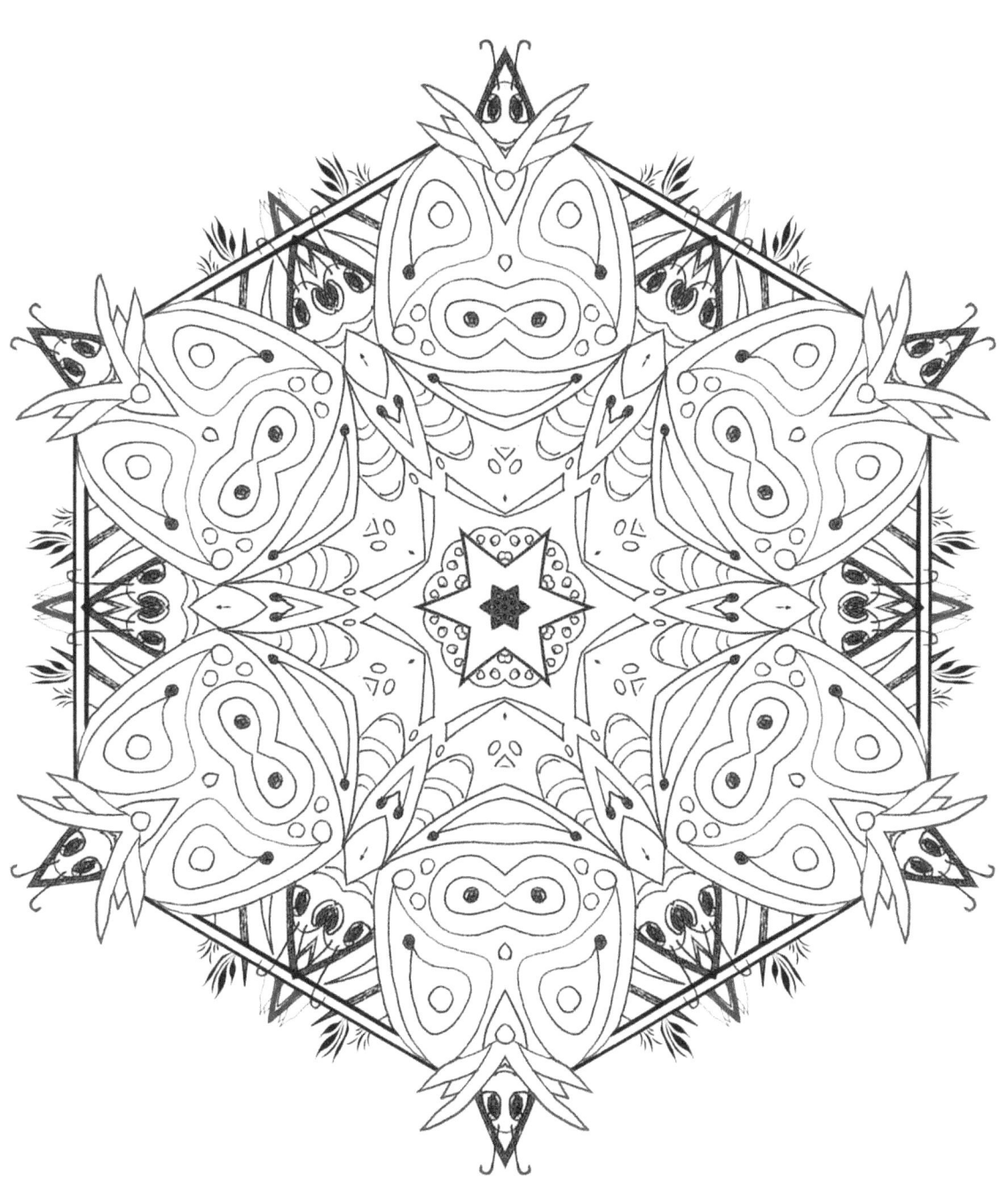

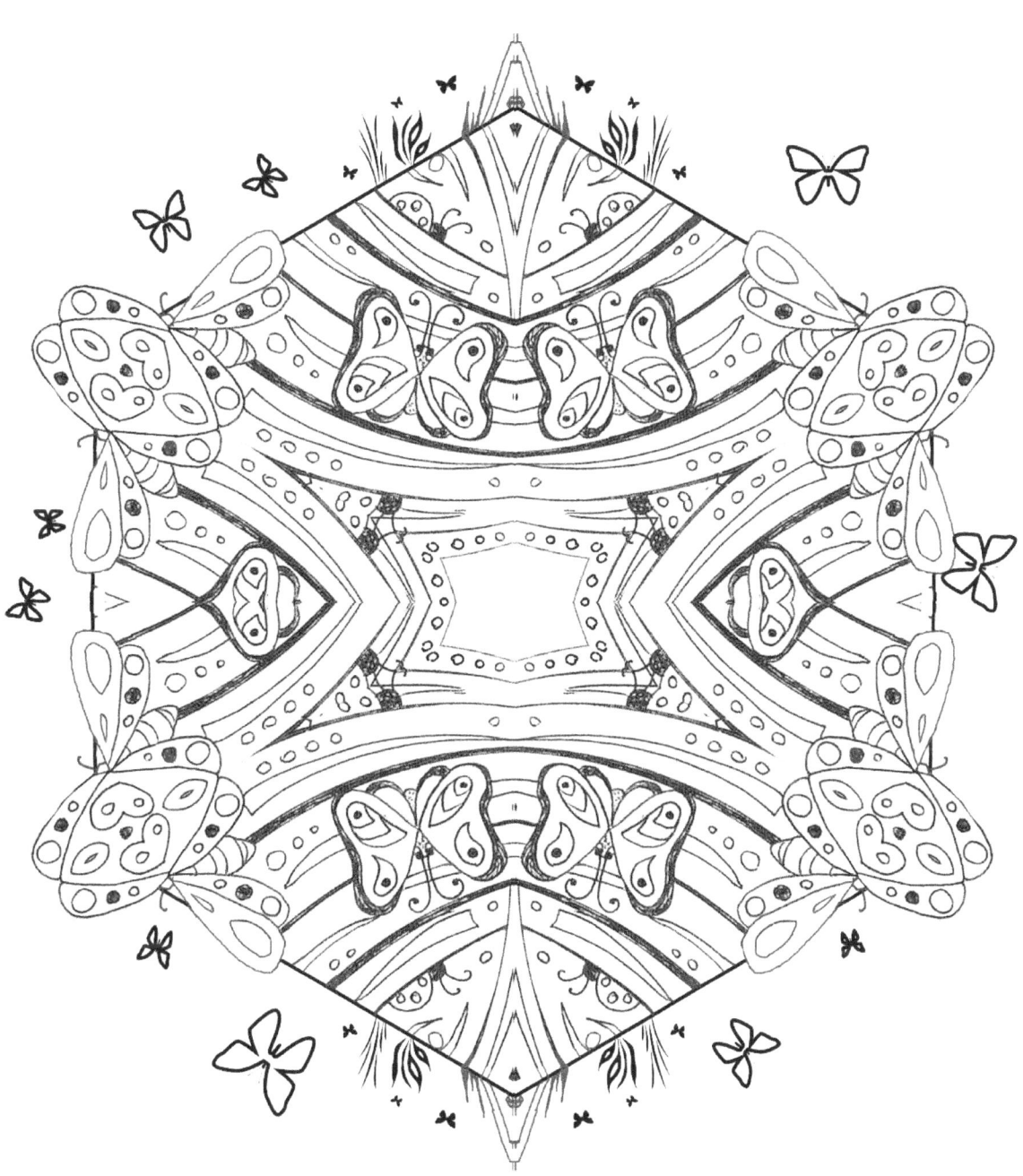

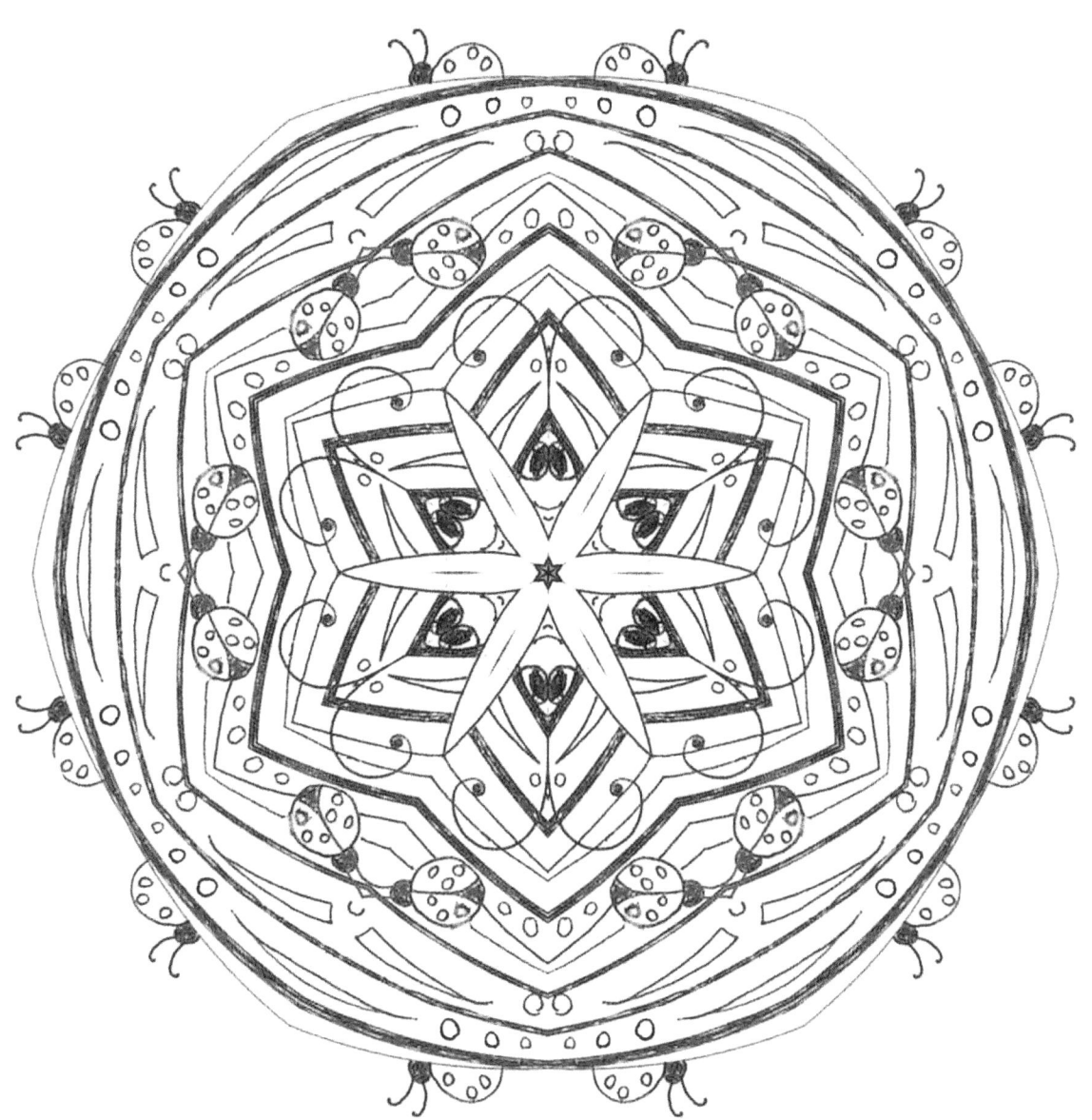

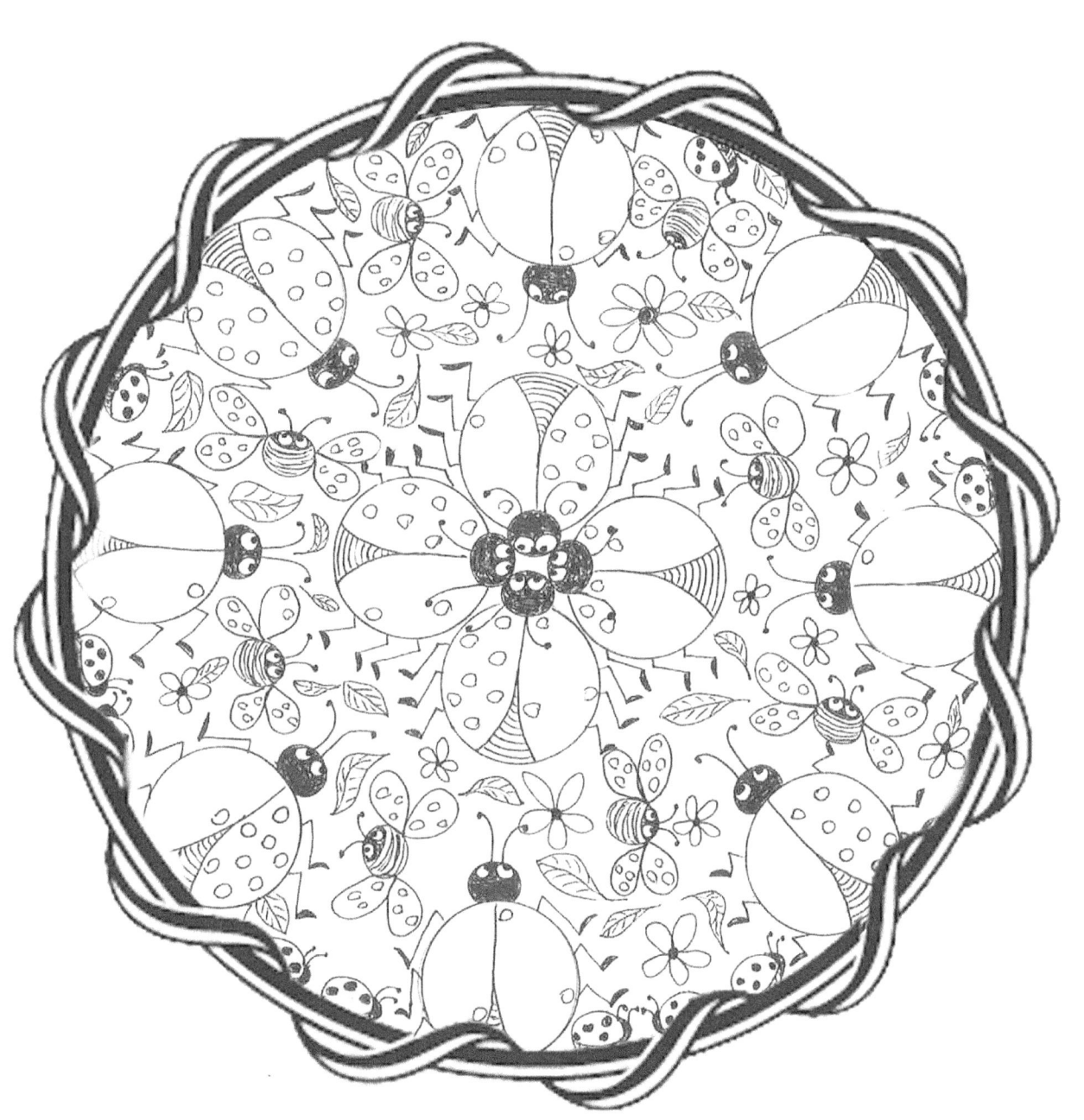

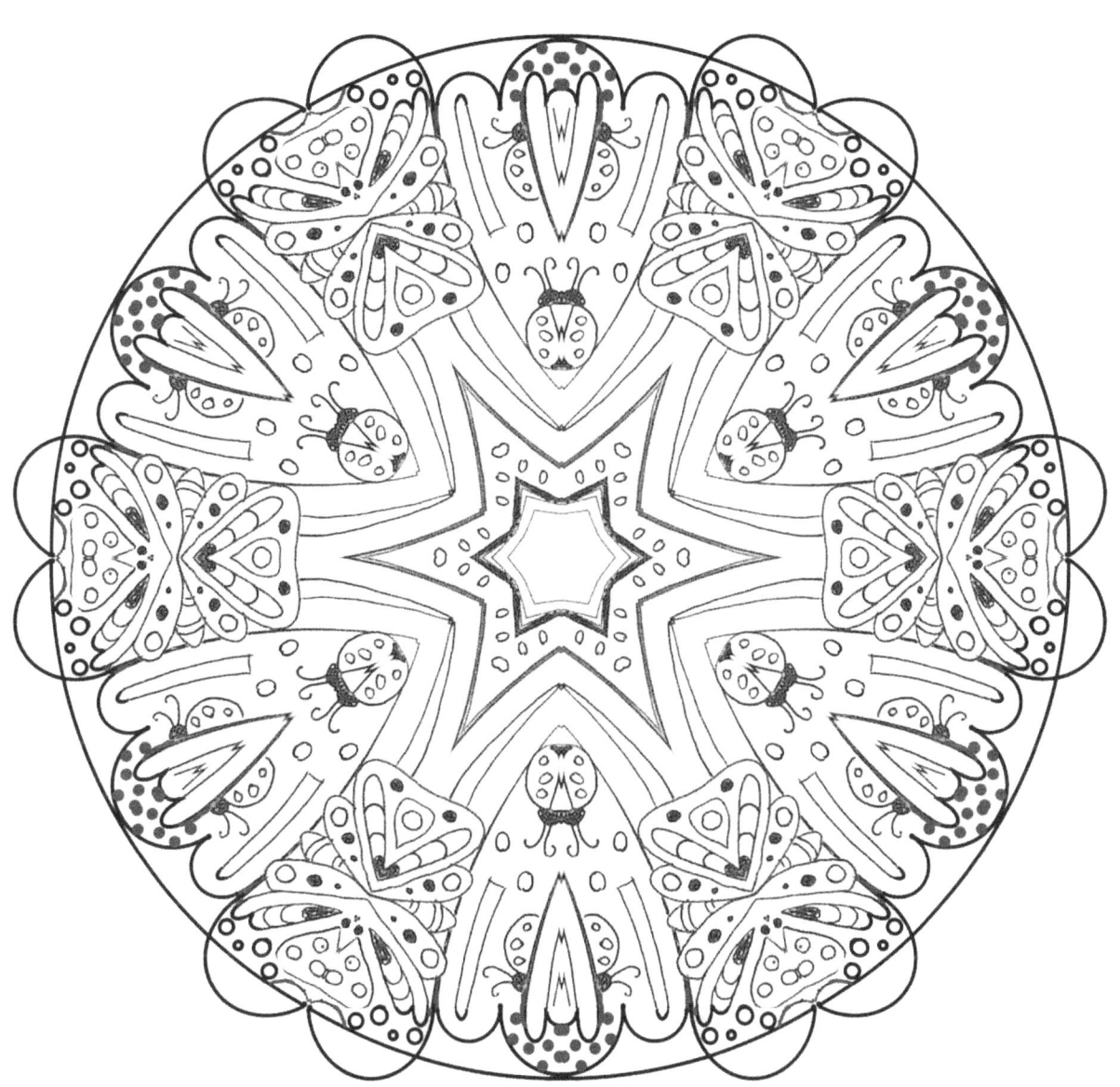

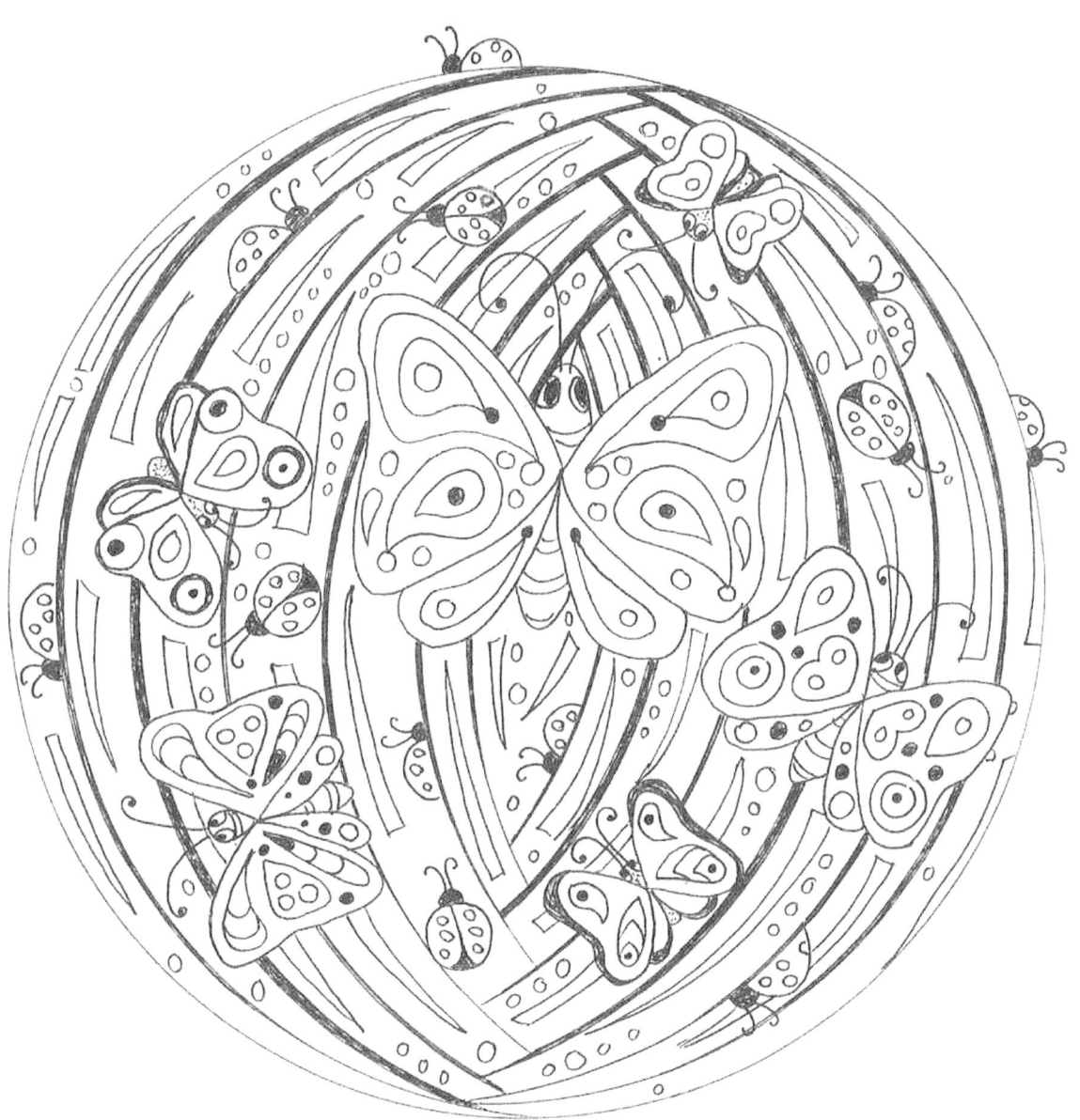

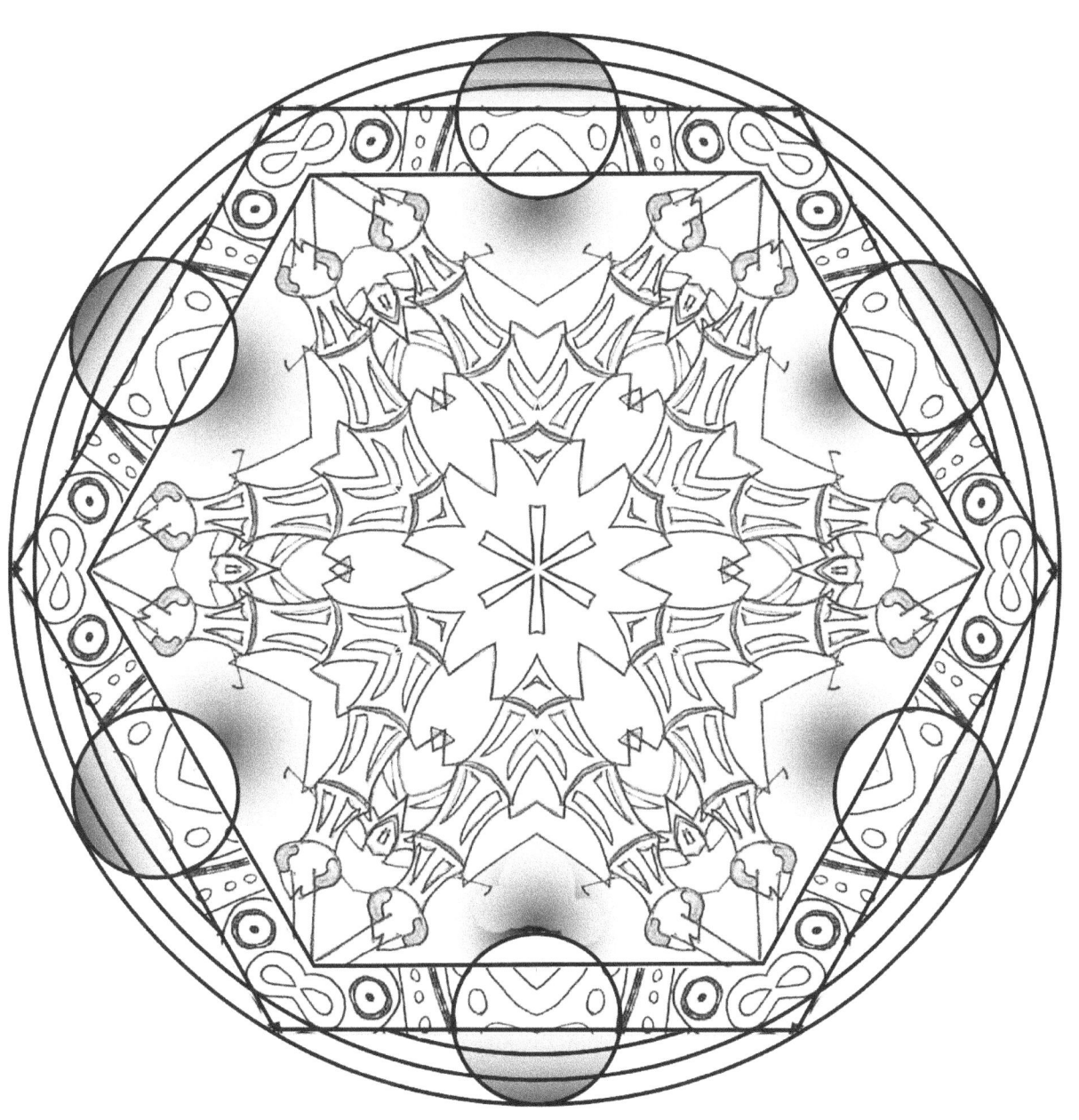

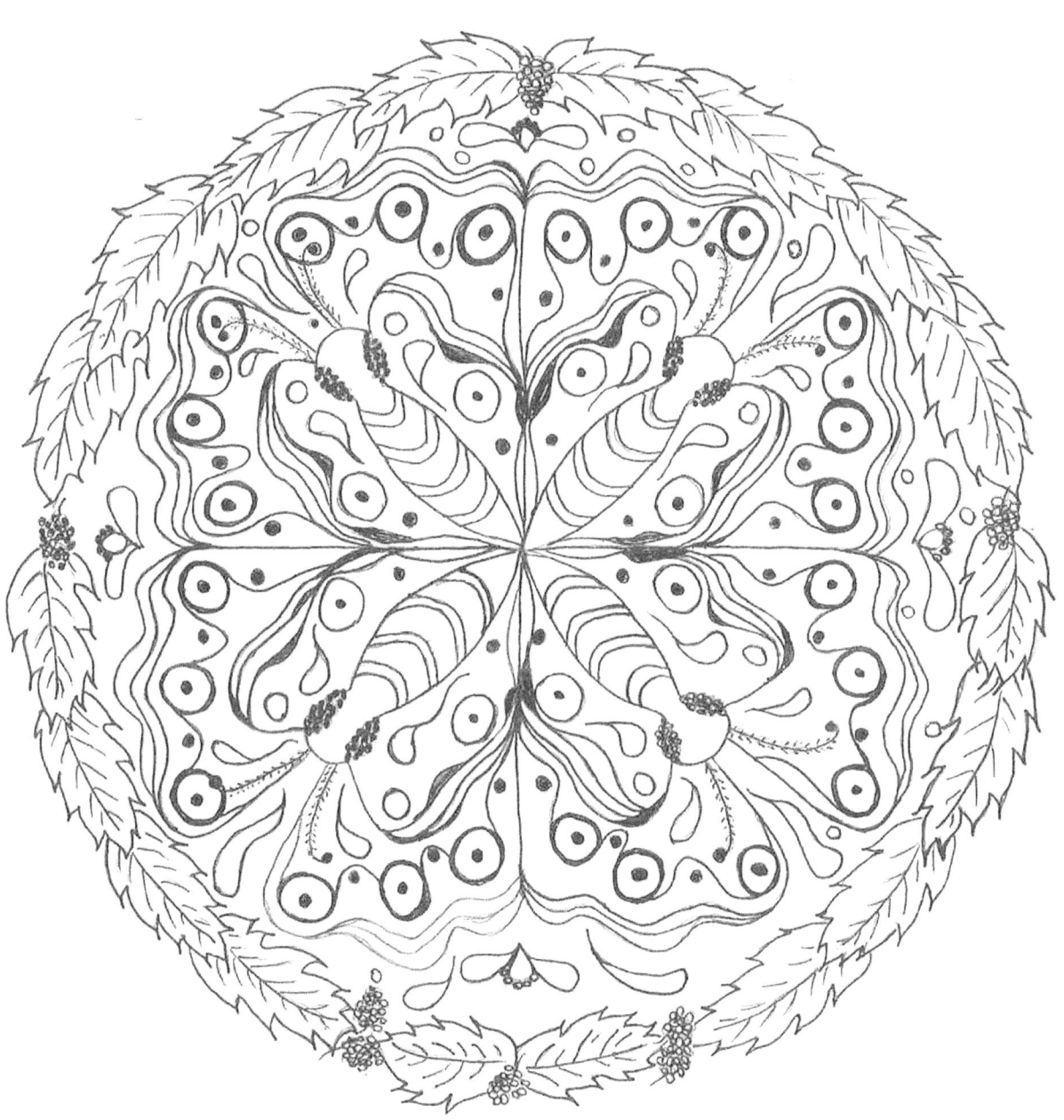

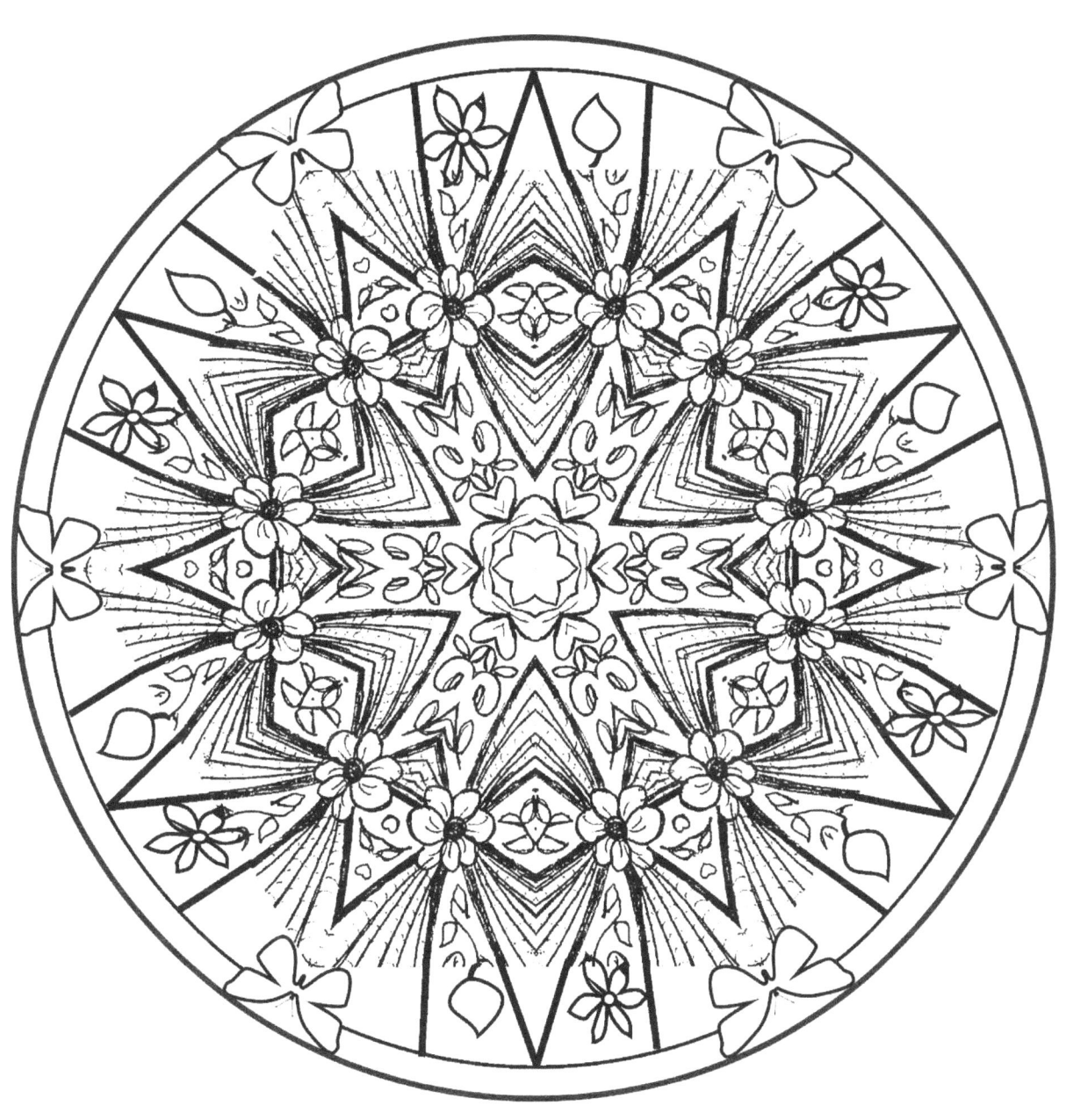

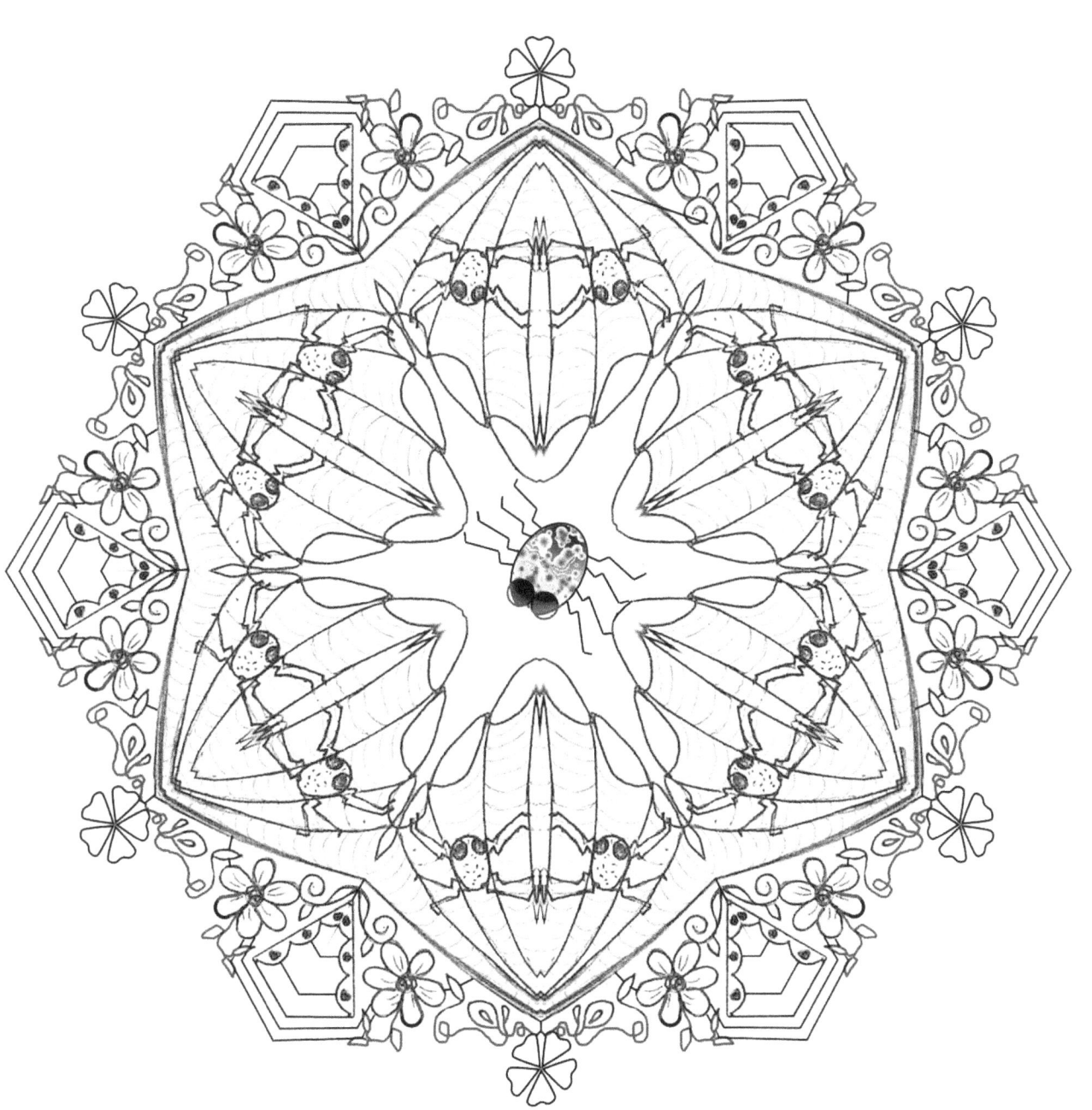

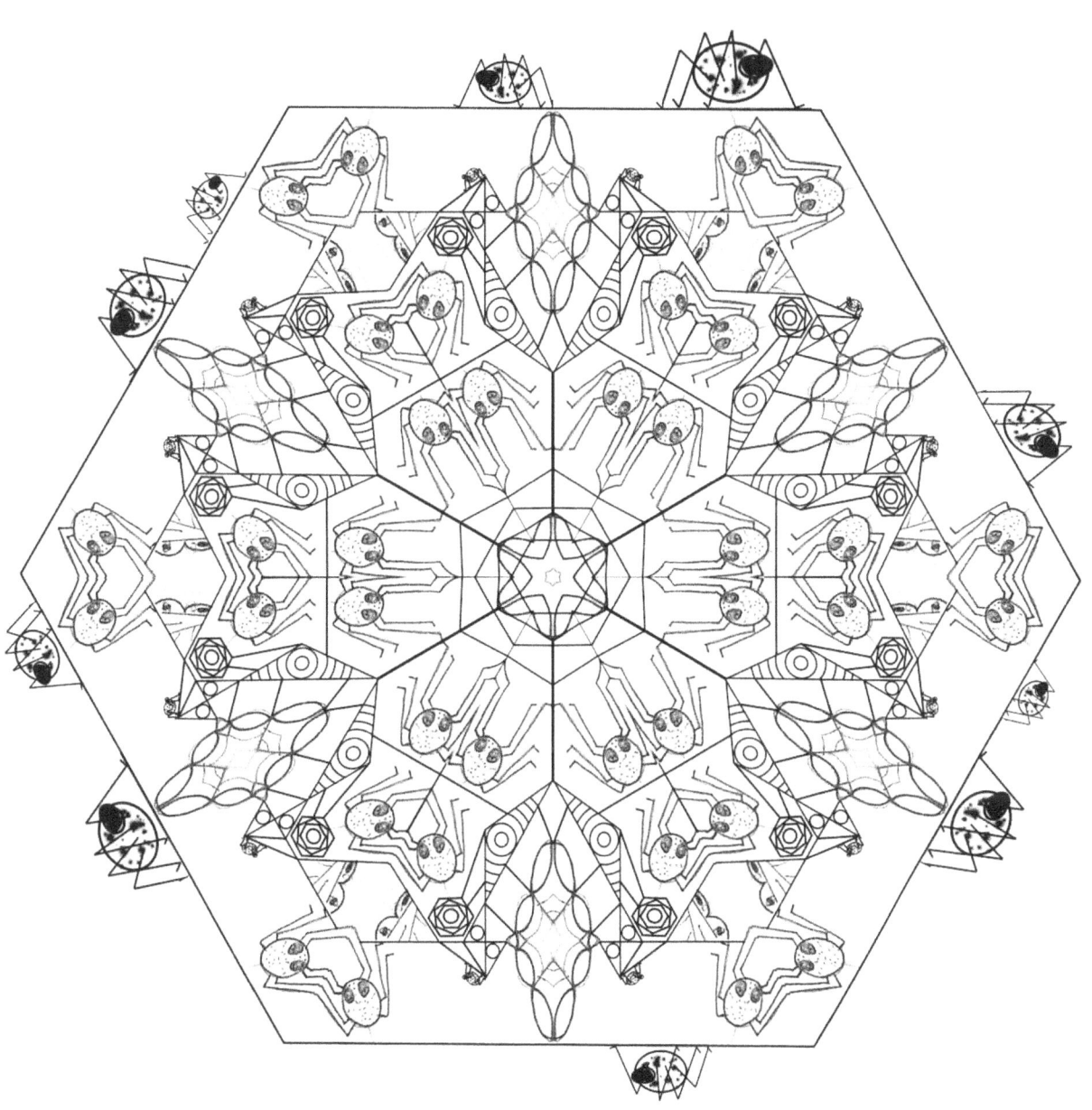

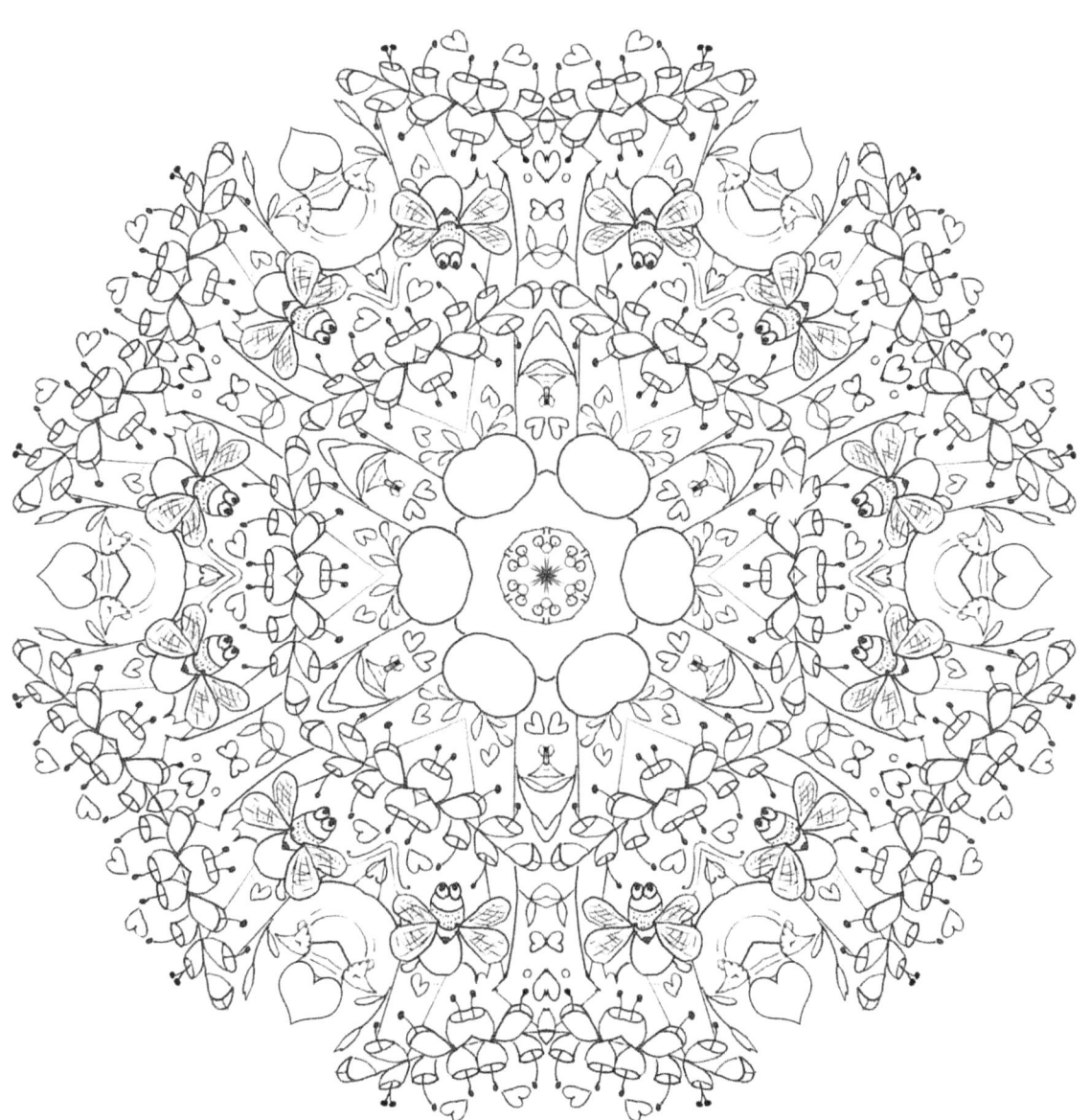

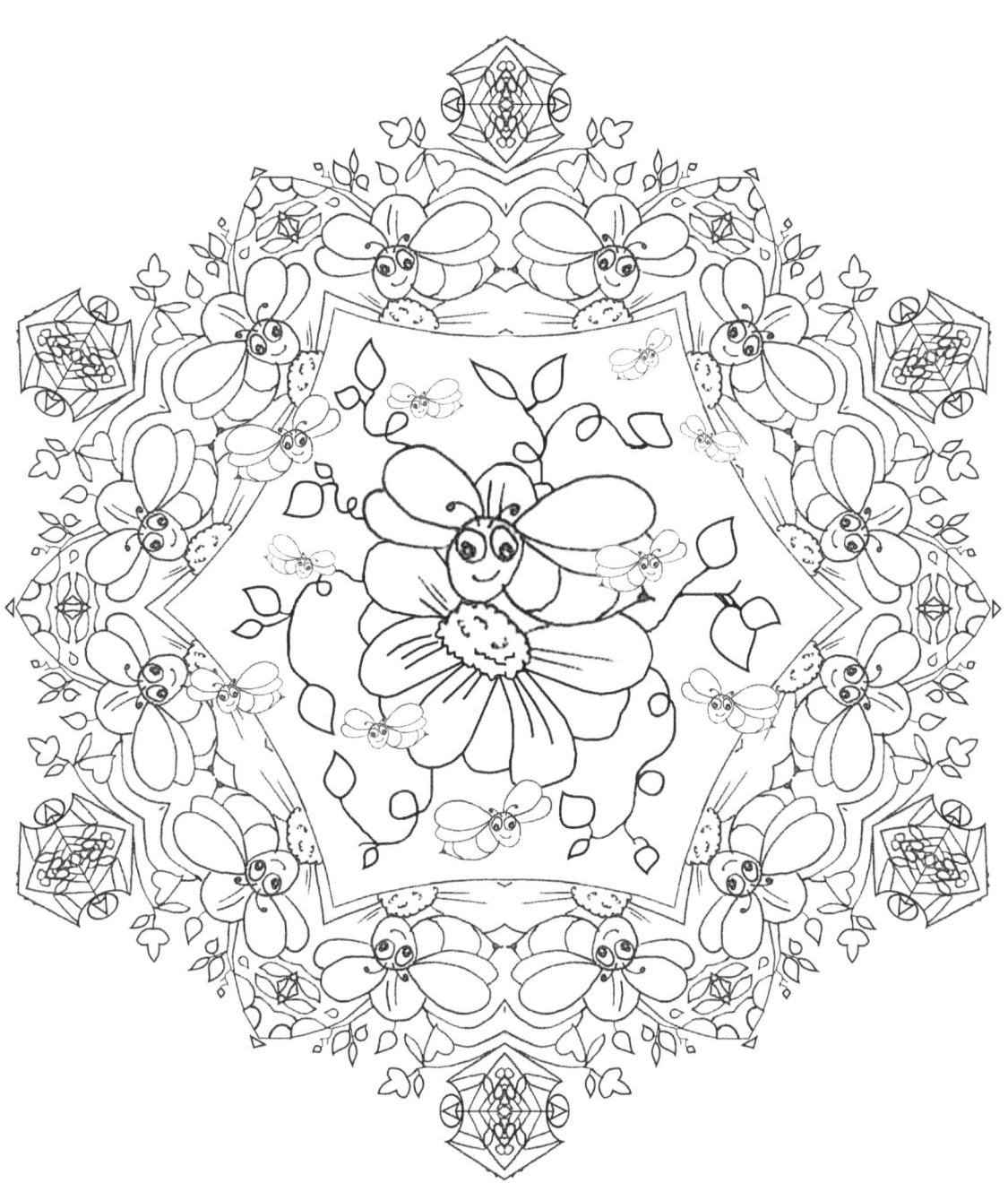

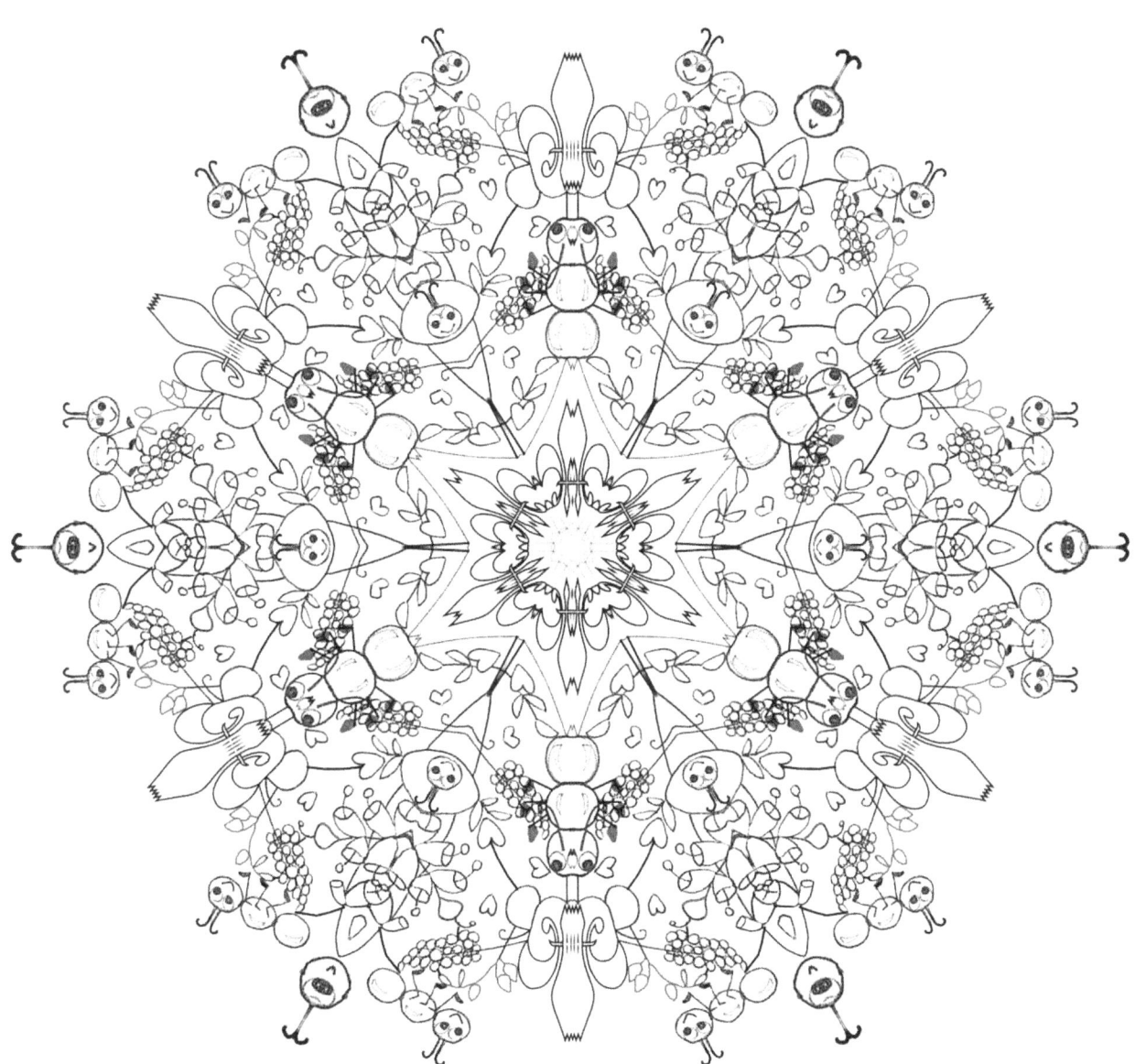

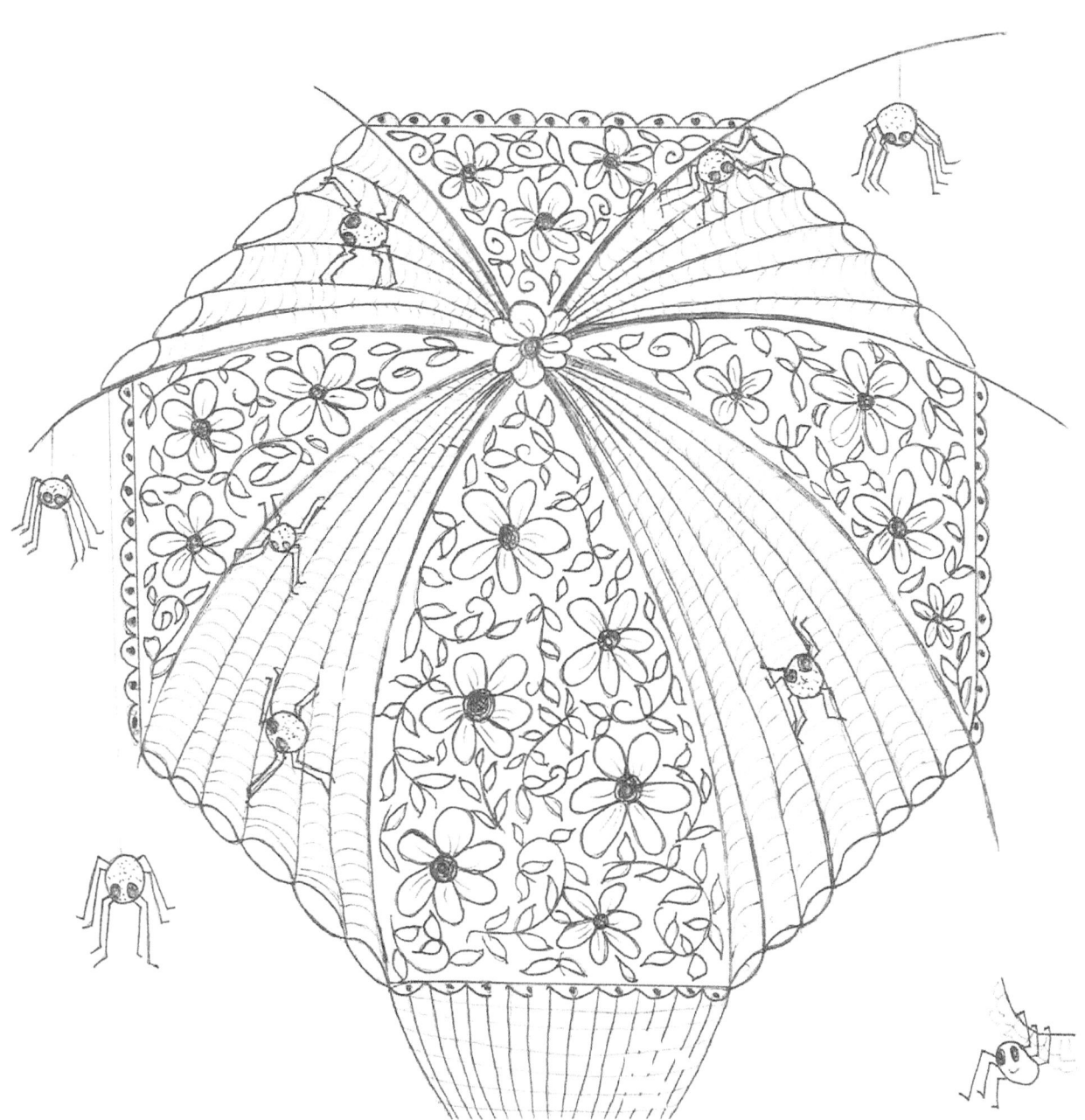

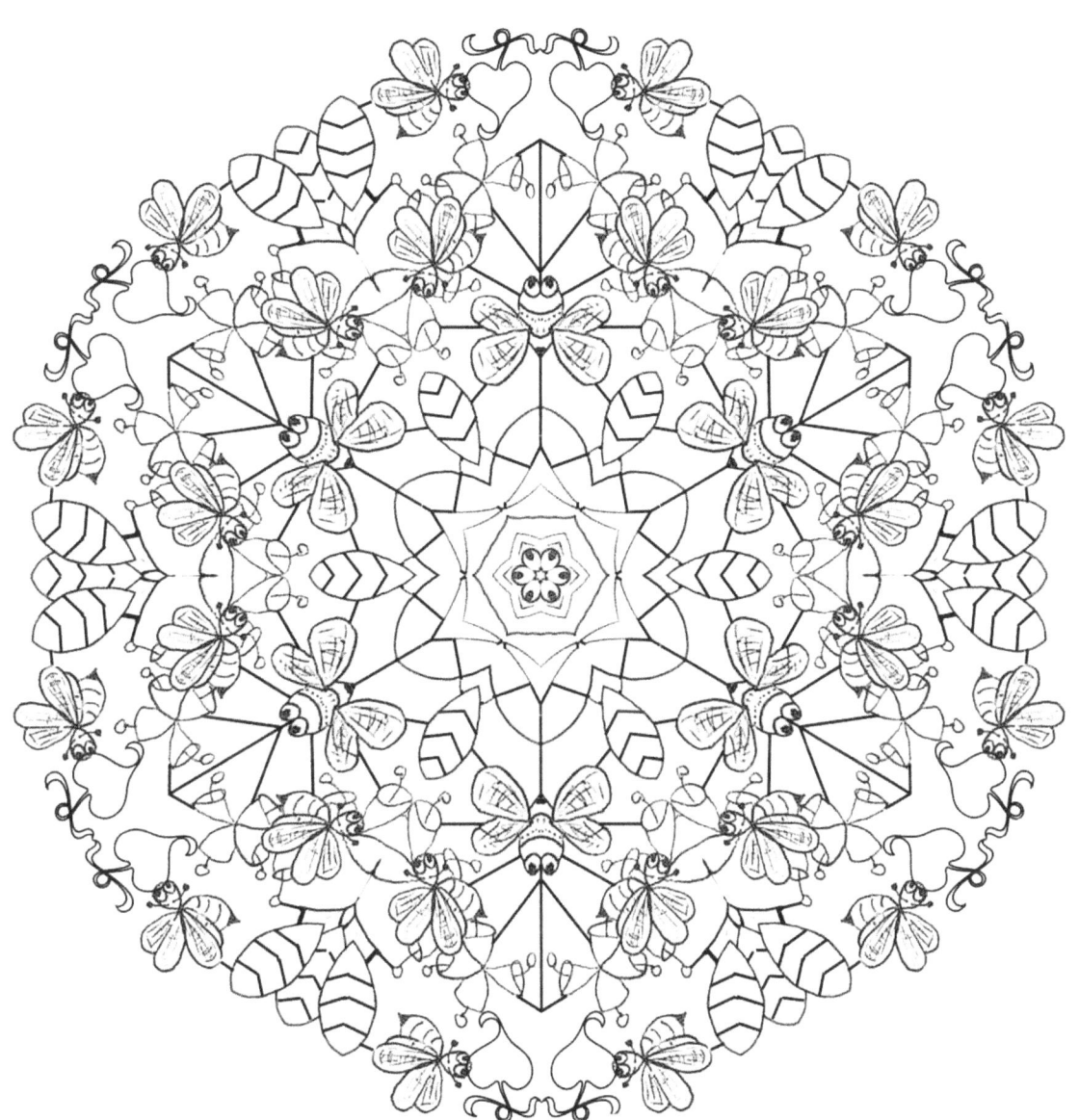

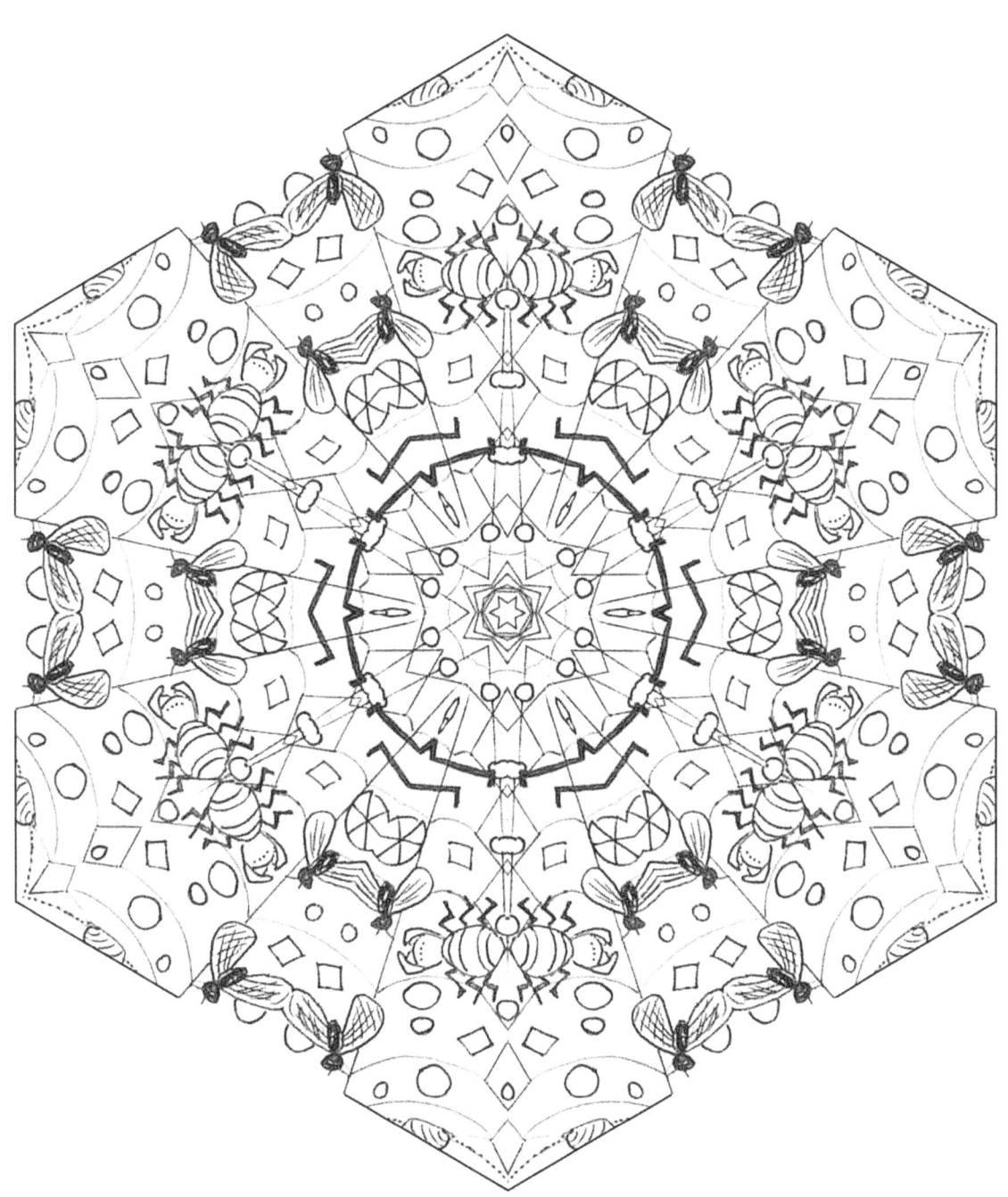

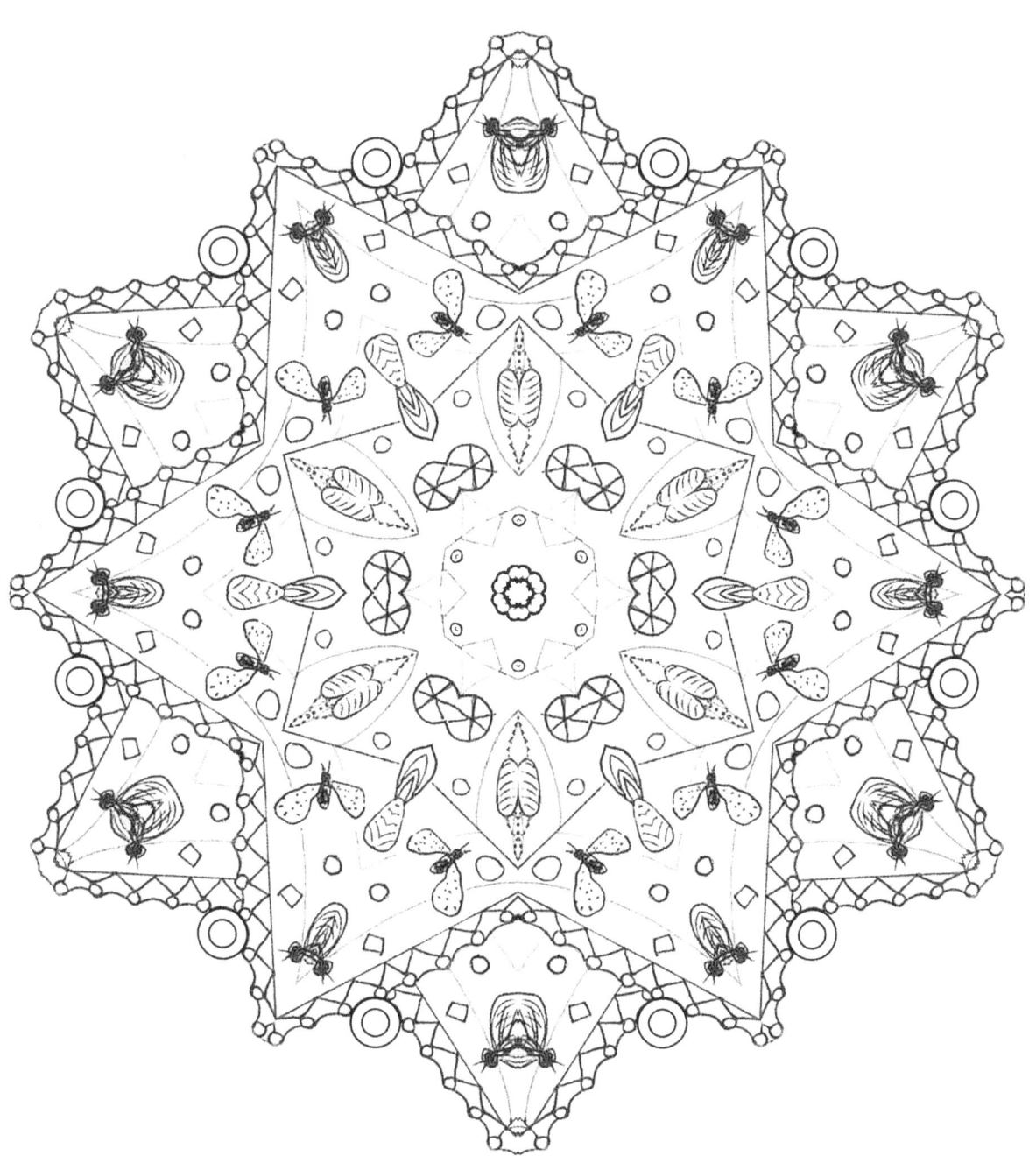

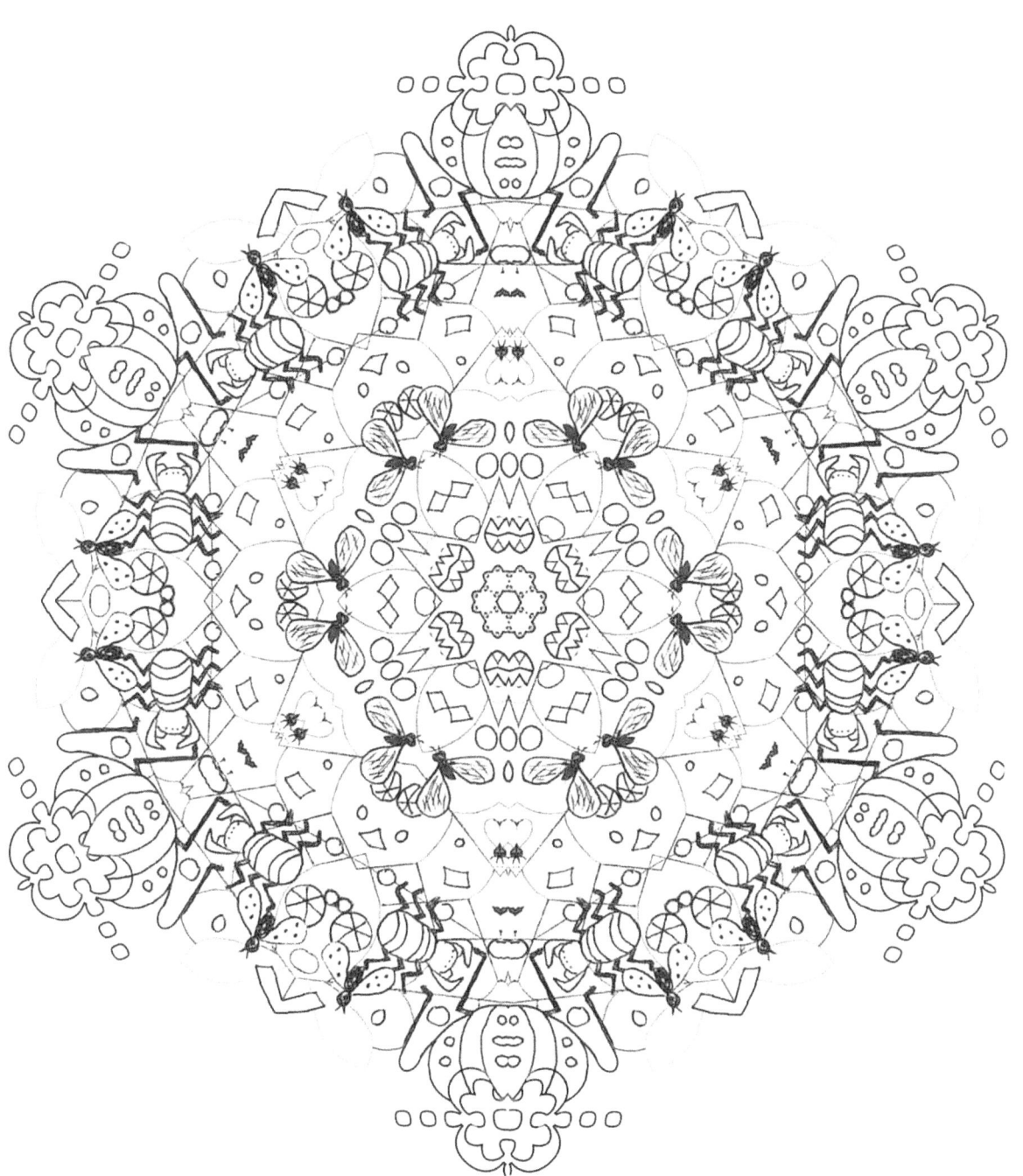

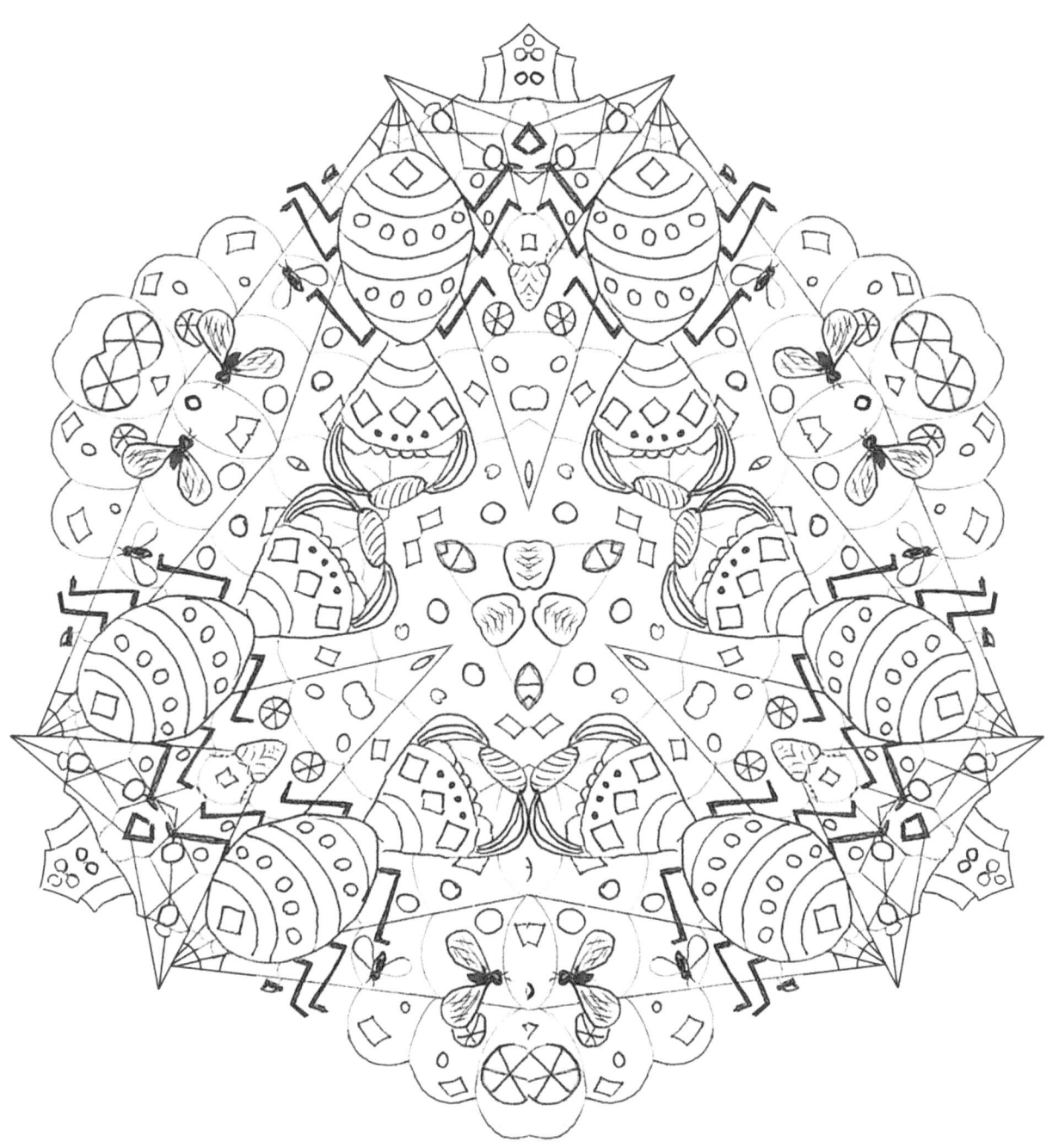

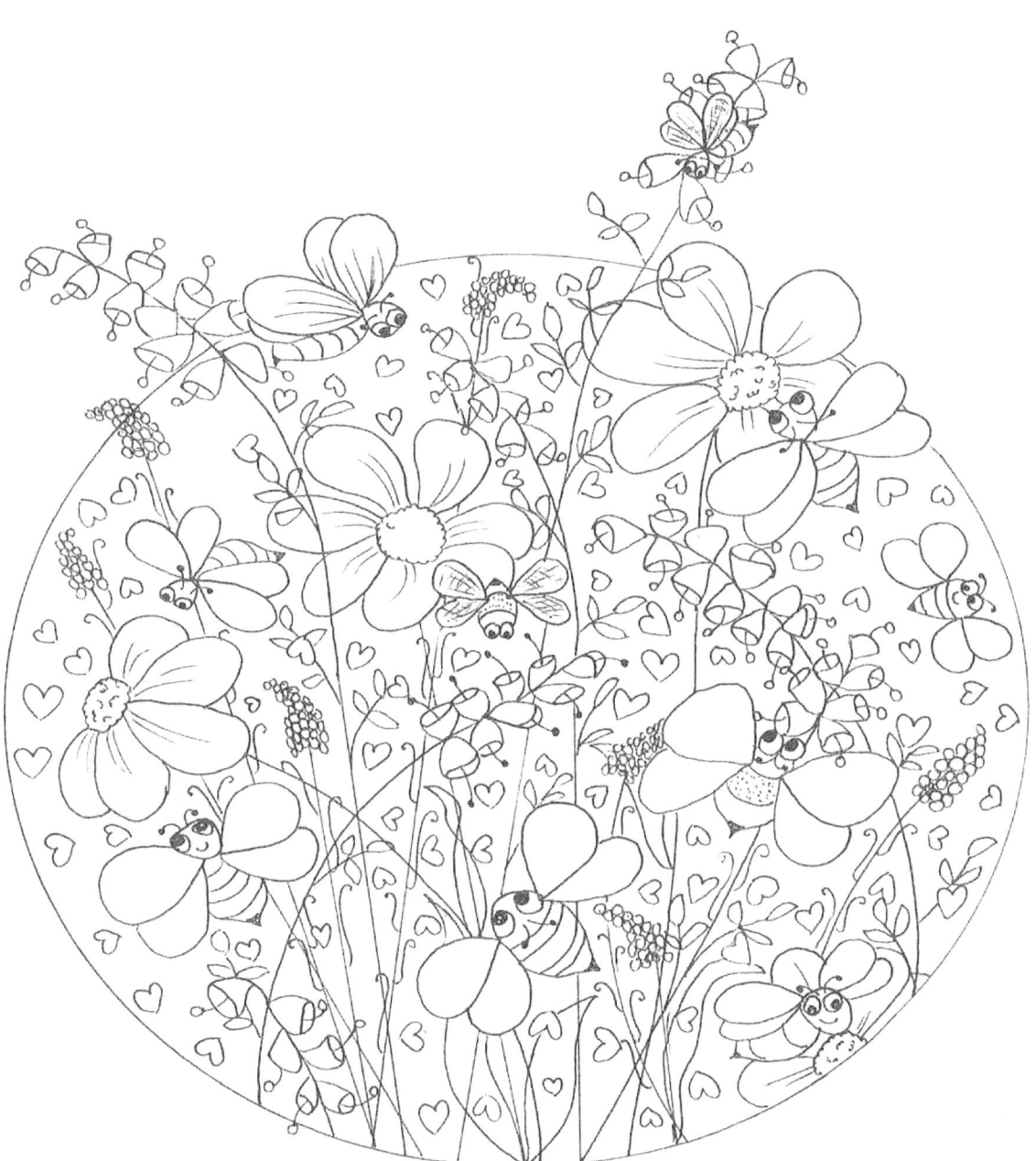

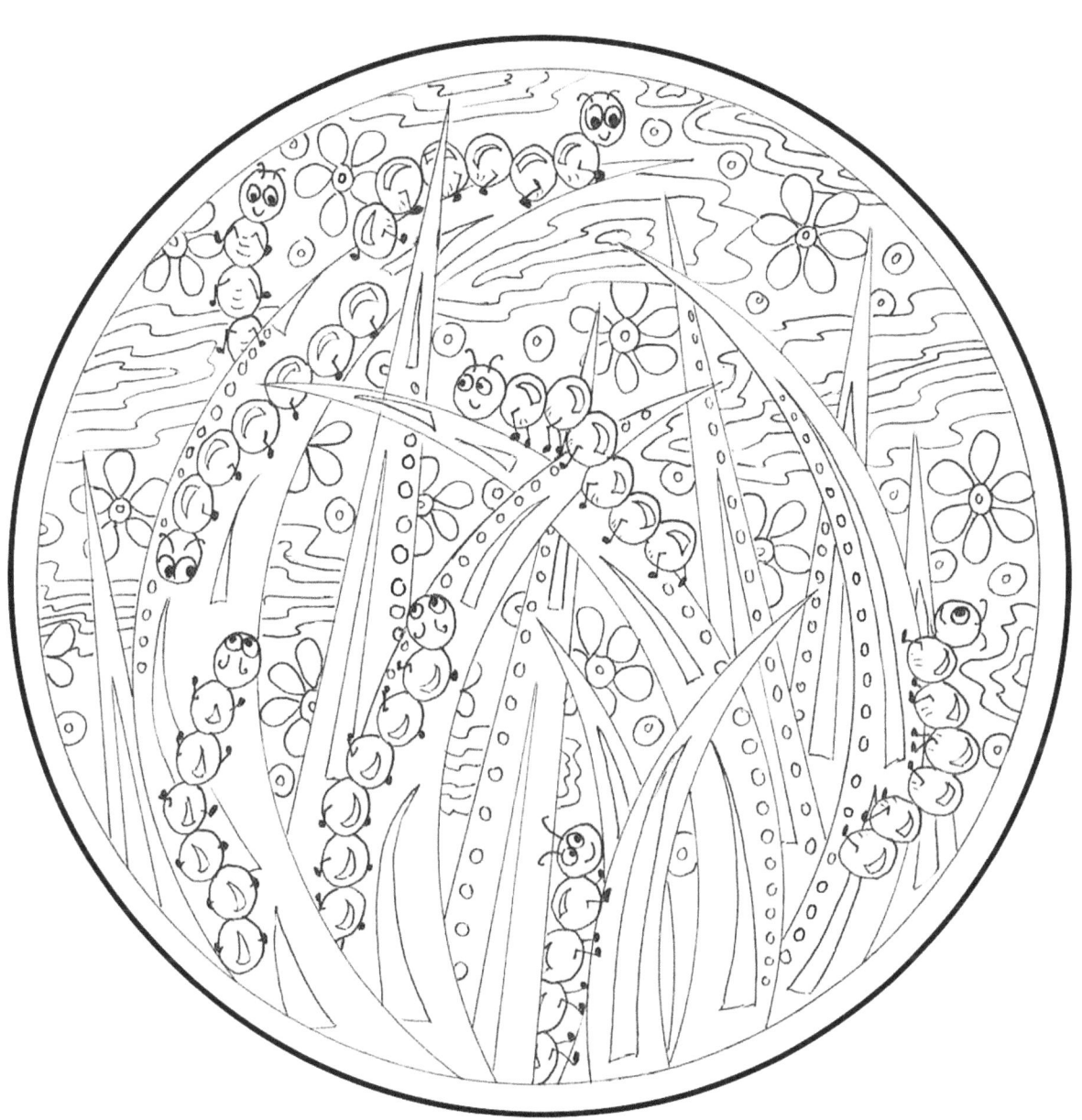

Conclusion

Thanks for all your hard work! I hope you truly enjoyed this book and found plenty of time to relax, unwind and create.

It's been a pure joy to bring these designs to you from our artists at SpectraGraf. If you would like more, please visit our site @ www.SpectraGraf.com where you will find books, art supplies, our exclusive coloring guide with color wheel and so much more!

You can also join our membership program there where you'll find a forum of like-minded artists from newbies to veterans – Everyone loves to color! Each week, members can download a new design from one of our many series.

You'll also find our SpectraShop where you can purchase all your books and supplies at members-only discounts.

Check there for contest dates when you can enter your completed artwork for a chance to win great prizes!

Go there NOW!

www. *SpectraGraf* .com

Now Available from **SpectraGraf:**

Pattern Power series – Volumes 1 thru 4

Mystic Mandalas series –

Geometrix - Volumes 1 thru 3

Organix - Volumes 1 thru 3

Whymsykyl - Volumes 1 thru 3

Paisley Passion series – Volumes 1 thru 3

See my Amazon Author page here.

Visit me on Facebook at https://facebook.com/spectragraf

Check out my tweets at https://twitter.com/spectragraf

Pin to my boards at https://pinterest.com/kennethrhorn

Look at me on Instagram

www.ingramcontent.com/pod-product-compliance
Lightning Source LLC
Chambersburg PA
CBHW080546190526
45169CB00007B/2653